Opposite
Tula women with water pots at the spring
at the foot of the cliff upon which lies
the village of Tula Wange, north-eastern
Nigeria. Head pads of dried leaves,
used in carrying the pots up and down
the cliff, are seen resting on some of the
pots. Photograph: W. B. Fagg 1949

Front cover
Terra-cotta group for the cult of
Ifijioku, the Yam Spirit, at Osisa, an Ibo
village to the west of the lower Niger,
Nigeria. 18½in (47cm)

THE POTTER'S A N AFRICA

Terra-cotta head discovered at Jemaa
south of Jos, Nigeria. It is one of the
finest examples of the ancient Nok
Culture. This is a photograph of the
original in the Jos Museum; there is a
replica in the Department of Ethnography.
8¾in (22cm)

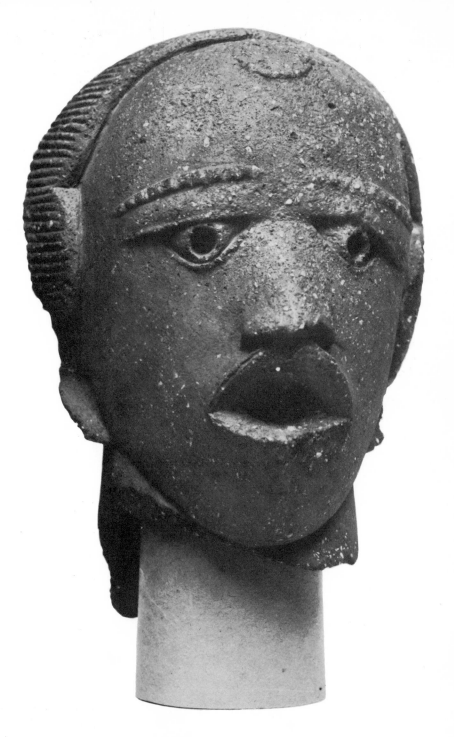

The Potter's Art in Africa

WILLIAM FAGG/JOHN PICTON

Published by the Trustees of the British Museum
London 1970

© 1970 The Trustees of the
British Museum
SBN 7141 1512 6
Printed in Great Britain by Shenval Press

The Ethnography Department is at
6 Burlington Gardens
London W1X 2EX

This selection, from the point of view of art, from the African pottery held in the Department of Ethnography has been chosen fairly evenly from the resources available. It is immediately evident from a perusal of the list of exhibition cases that whereas there is a reasonably adequate coverage of many of the areas in which British people have worked during the past century or so, other areas, such as those frequented by Frenchmen during the same period, are almost totally lacking in our collections. There are some notable exceptions, such as the great Kabyle collection which we owe mainly to Mrs Eustace Smith about the turn of the century, and of course the Bakuba collections from the Congo, made by Emil Torday a few years later (and the Congo collections have been further supplemented by very numerous, though undocumented, specimens in the benefaction of the Wellcome Historical Medical Museum in 1954). Steps are now being taken wherever possible to obtain collections from other areas, beginning with the fine collection from the Gbaya of central Cameroon, perhaps the most famous of African potters, made by the University College of Wales Central Cameroon Expedition in 1969.

There is a singular dearth of good ethnographical works in English on African pottery, but there is an excellent short account of it in Margaret Trowell's *African Design*, London 1960. Her book with K. P. Wachsmann, *Tribal Crafts of Uganda*, London 1950, gives a very intensive account of the pots of one country. Michael Cardew in his recent book *Pioneer Pottery* (London 1969) may be warmly commended for the love and enthusiasm for African pottery which he is capable of imparting to all his readers or hearers. Finally, among many articles on the subject which have appeared in *Man* in the course of the century, mention may be made of one by W. E. Nicholson on 'The Potters of Sokoto, Northern Nigeria' (*Man*, Vol. XXIX, 1929, article 34, pp. 45–50).

In preparing this exhibition we have had invaluable help from Doreen Nteta of the National Museum of Botswana and from Susan Picton, lately of the Nigerian Department of Antiquities. Her photographs in this booklet and in the exhibition are reproduced by permission of that Department, and Philip Stevens's photographs by permission of the University College of Wales Expedition to Central Cameroon. Dr René Gardi is thanked for two photographs (from *Unter afrikanischen Handwerkern*, 1969) and Sam Haskins for one photograph (from *African Image*, 1967) used in the exhibition. William Fagg took the photographs from Ishan-Ekiti, Nigeria, in the exhibition besides those noted herein.

William Fagg
John Picton

Overleaf
Funerary pot, *abusua kuruwa*, placed on three small pots representing hearthstones, from Abuakwa, north-west of Kumasi, Ashanti, Ghana. 11in (28cm), 'hearthstones' 6in (15cm)

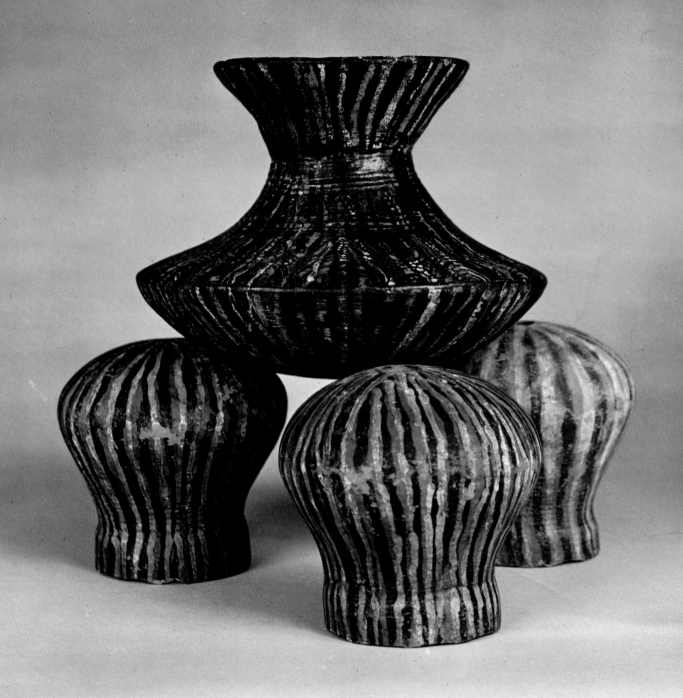

Pottery as art

This exhibition is about pottery and pottery sculpture (also often called terra-cotta) as art rather than craft, emphasising forms rather than techniques. The distinction between pottery and pottery sculpture (terra-cotta) does not, therefore, imply that one is not art while the other is. For one thing, whereas in Europe the potter and the sculptor using the medium of terra-cotta are unlikely to be the same person, in Africa with certain exceptions the reverse is true. Potter and potter-sculptor are often the same person, or at least products of the same training. Perhaps because of this the very distinction between pottery and terra-cotta is frequently unclear, as must be evident from this exhibition, and is anyway an artificial aid to help us to classify the objects rather than separate categories used by the makers and users themselves.

In any case a pot does not become a work of art only if a sculptor or painter had some part in its making. Pottery does not rely upon sculptured ornament or painted decoration in order to qualify as art; it relies upon its own counterpoint of form, colour, texture, and ornament all directed towards a particular purpose. Admittedly that purpose is usually domestic, but pottery is no less art for that. As Michael Cardew says 'the art of pottery is about pottery'.

Nevertheless, in Margaret Trowell's terms (*Classical African Sculpture*, 1964), all or most of the pieces which we have called terra-cottas may be considered 'spirit-regarding', whereas useful pots are, though in a slightly different sense, 'man-regarding' – which of course includes 'woman-regarding'.

The earliest pottery

The art of pottery seems to have been first discovered around the sixth millennium BC in the Middle East at Jericho in Palestine and spread into parts of North Africa soon after. The Kabyle pottery from Algeria exhibited here probably represents a Mediterranean tradition dating back to 2000 BC. In Africa south of the Sahara, however, the area from which come most of the pots on display, the earliest pottery so far discovered may date back to the fourth millennium BC.

The Nok Culture

The earliest pottery sculpture so far discovered belongs to the Nok Culture of northern Nigeria. This culture also includes domestic pottery, polished stone axes, and evidence of early iron-working. There are a great many sites, mainly in tin-bearing alluvial deposits, over a wide area of the so-called Middle Belt of Nigeria (i.e. the Benue and middle Niger valleys and an extension northwards to include the Jos Plateau), and in date they may cover a period of about a thousand years beginning in the middle of the first millennium BC.

The most remarkable artifacts of the Nok Culture are, of course, the pottery heads and body fragments, some of which are near life size. It is wise to refer to Nok as the earliest *so far* discovered for it is remarkable that even at 2,500 years ago these sculptures show no signs of primitive beginnings. On the contrary, there is an astonishing range of different modes of treatment of the human form. As yet it is obviously impossible for us to know whether Nok sculpture has any antecedents either in pottery or in some other medium, in the same or

Woman potter of the Ham (Jaba) tribe
of northern Nigeria walking round a pot
as she forms it. Photograph: W. B. Fagg
1949

some other part of Africa. Indeed, the Nok Culture itself might have remained undiscovered if it had not happened to lie in the same deep alluvial beds as the tin which has been mined with all the resources of industrial civilisation.

The people of the Nok Culture may well be ancestors of some of the numerous small tribes which inhabit that part of Nigeria at the present time. The women of those tribes still produce pots of similar, though generally larger forms (which is no evidence in itself), as well as rather less similar pottery sculpture for thatch finials, grave memorials, and a variety of religious purposes.

Ife
Another great terra-cotta sculpture tradition is that of Ife in the Yoruba area of Nigeria. The Yoruba are very different in most ways from the tribes of the Middle Belt, yet there are important points of similarity in style and in technical achievement between the pottery sculptures of Nok and Ife, and it may well be that the Nok Culture played a significant part in the development of sculpture at Ife. These two cultures are alone in Africa in having produced near-life-size human figures in pottery; this indicates similar technological achievement and therefore ability. Moreover, the renowned naturalism of Ife is in fact much more applicable to the faces of its sculptures, and the body fragments from Nok and Ife are remarkably similar, to the extent of being often almost identical. It is therefore possible that the sculpture of Ife is descended from that of Nok but with naturalistic elements superimposed. The technological ability needed to fire large pottery objects

successfully would facilitate the development of bronze-casting and the transference of the sculpture from one medium (that of clay) to another (that of wax – *cire perdue*). A difficulty about this hypothesis is, of course, the gap in our knowledge concerning the several hundred years between the presumptive end of the Nok Culture and the beginning of Ife, now dated by radio-carbon to about the eleventh or twelfth century AD. Together with this is the fact that the known terra-cottas and bronzes of Ife clearly existed side by side and probably were made by the same group of sculptors. In other words we have no evidence of the immediate antecedents of Ife sculpture.

In another respect Ife is a unique town: large areas (they may eventually prove to be enormous areas) were paved with neatly trimmed potsherds close set on edge, often in several layers. These pavements not only seal the archaeological deposits, but provide a remarkable opportunity for an exhaustive study of pottery styles.

Women as potters: exceptions
Women are makers of pottery in Africa; their hands dig clay from the earth, pound it ready for use, mould it and smooth it, decorate and fire it, and finally take the finished objects to market. However, there are exceptions.

In Ashanti, reports Rattray, it is forbidden for women to make pots which incorporate anthropomorphic and zoomorphic decoration. These are made exclusively by men, although all other pottery is made by women. The reason given is that there was once a famous woman potter who is said to have become

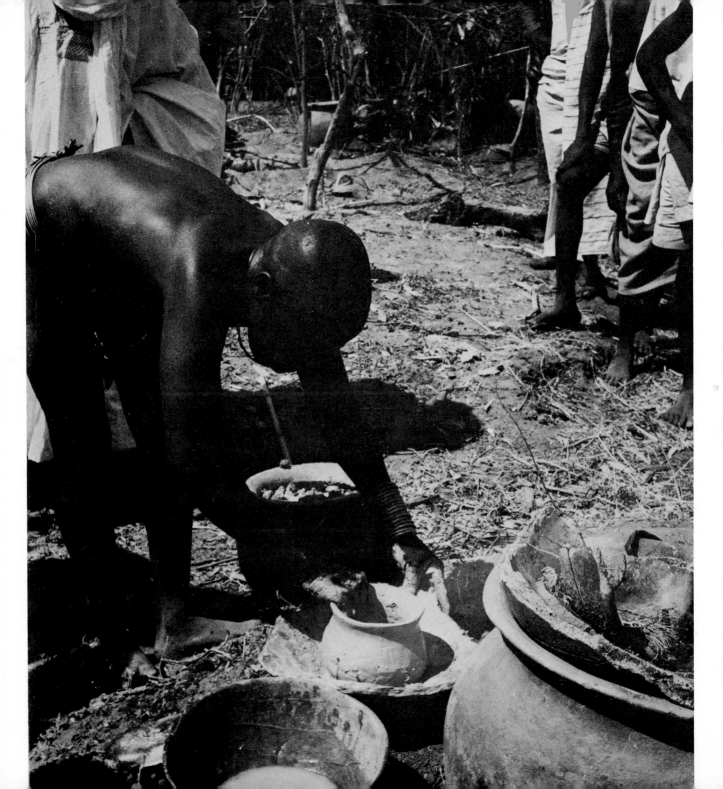

Two pots made by the woman potter
Pauline Bazama of the Gbaya tribe,
central Cameroon, in 1969, and
burnished with graphite. 15 and 27in
(38 and 68cm)

barren after she had modelled pots with human figures on them. Her sterility was presumably ascribed to the confusion between her natural role as childbearer and her ability to make the human image in clay.

At ancient Ife it is almost certain, for reasons of style, that the terra-cottas were made by the same group of men responsible for bronze-casting, just as at Benin from the fifteenth century to the present day bronze-casting and terra-cotta sculpture have been in the hands of the same men. Bronze-casting is a male preserve, and the Benin bronze art was traditionally borrowed from ancient Ife. However, at the present day terra-cotta sculpture among the Yoruba is made by women.

A third exception are the men of the Adarawa Hausa of Sokoto who are responsible for much of the domestic pottery used in that area (although the women make some of the smaller pots). Perhaps this is related to the custom of purdah which is probably more rigidly adhered to there than in most other parts of Nigeria. At any rate their technique of pot-making is significantly different from that used by women potters, and may derive in part from the technique of beaten metalwork.

The division of labour between the sexes in Africa is usually marked and rigid and they are very rarely responsible for the same sort of work. Even in the examples quoted it will be observed that if men are involved in pottery, which is normally women's work, either they make a different sort of object, or they use a different technique. (Similarly with weaving: in some cultures all cloth is made by women, in others by men; but wherever both women and men within the same culture weave cloth they use very different types of loom.)

Techniques

This exhibition, being about art rather than craft, is not primarily concerned with technique; but if we can understand something of the techniques used we shall appreciate better the nature of the potter's art in Africa.

Pots and terra-cotta sculptures are moulded by hand instead of thrown on a wheel. Although the potter's wheel is now in use at government trade centres and the like, the traditional methods of beating and coiling the clay are still the standard methods throughout most of Africa and are not yet in danger of being lost. In fact hand building is probably more difficult to master than throwing on a wheel, and as a training in co-ordination and of a sense of form it is probably superior. So a wheel is not needed in order to make good pots, as this exhibition clearly demonstrates.

Pots and terra-cotta sculptures are made using more or less the same techniques and, as we have said, the potter and potter-sculptor are often the same person. The potter first prepares her clay simply by pounding the selected earths with water. After she has done this, a lump of clay is placed on some sort of stand and the potter makes the base by hollowing out and dragging up the clay. On to this she adds short thick coils moulded in the palms of her hands. In order to mould the pot to the required shape and smooth it she walks backwards around the pot, although in some areas the potter is seated and she turns the pot in front of her with one hand (or occasionally a toe), moulding and smoothing it with the other hand. Large water pots are often made by coiling the upper half of the pot first, and

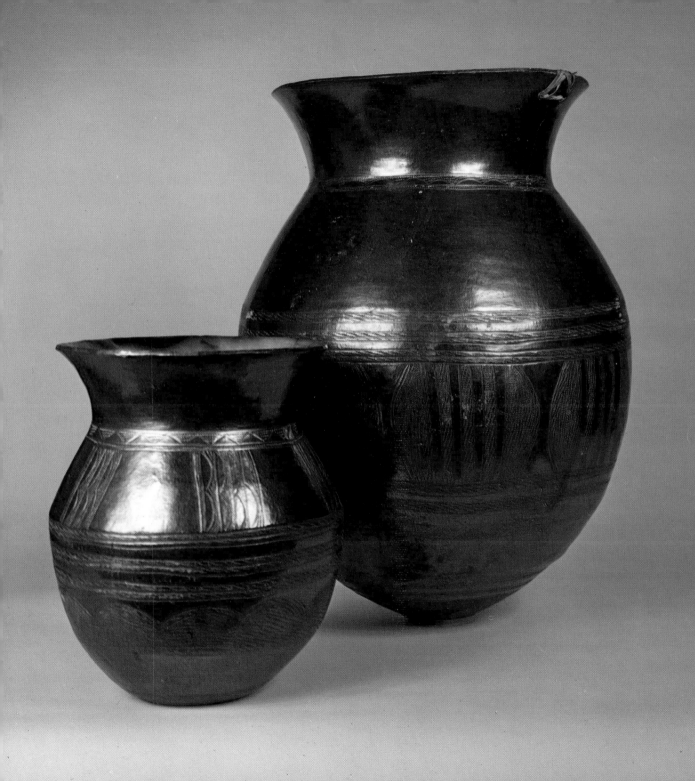

Woman potter shaping the neck of a
pot in the Yoruba village of Ishan-Ekiti,
Nigeria, a noted centre of pottery-
making in the area. Photograph:
W. B. Fagg 1959

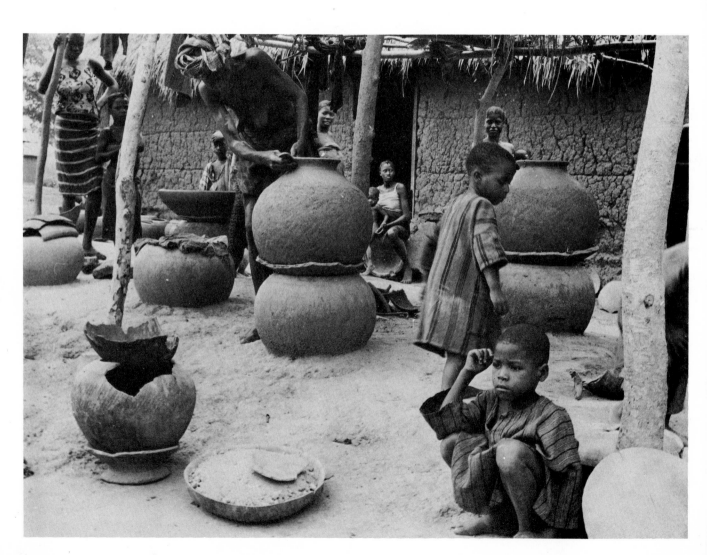

Pauline Bazama, a noted Gbaya
potter, of Beka-Goubia village, central
Cameroon, burnishing a pot with graphite
from the slurry in a dish at her right hand.
Photograph: Philip Stevens 1969

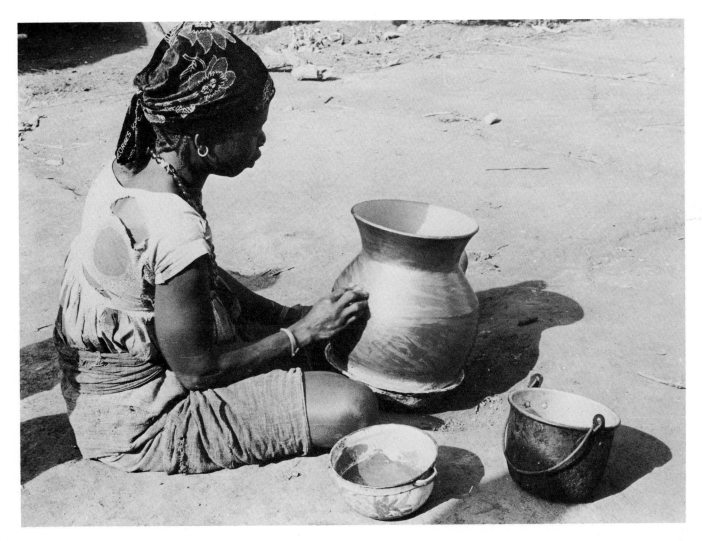

then when it is stiff enough it is turned upside down and the bottom of the pot is coiled on. Ashanti women in Ghana, however, make the entire pot by hollowing out and dragging up a solid lump of clay; no coiling is done at all. The clay is placed on the ground and the potter walks backwards around it bent double.

The Adarawa Hausa men potters of Sokoto build the entire pot by beating out the clay with small clay pestles. The potter sits with the clay in front of him either in a small depression in the ground or resting on a mould. As he beats the clay, to the shape imparted by the mould or depression, he turns it with one hand or with his feet until a spherical pot is built.

When the modelling of the pot is complete it is left to dry in the sun and then stored ready for firing. When a sufficient number are ready they are stacked on top of a layer of brushwood and covered with grass which is set on fire. The fire can last from about fifteen minutes up to a couple of hours depending on how much grass is thrown on to the fire to keep it burning, and the practice in this regard varies from place to place. Where pots are fired only for a very short time, the purchaser may fire her pot a second time when she brings it home.

The kiln, like the potter's wheel, is invariably the mark of a post-tribal situation, and – again like the potter's wheel – in most of Africa it is only found in government trade centres and the like. The only exception is that in a few places in West Africa the pots are stacked for firing in an area marked by a low wall and fuel is added during firing through gaps in the base of the wall.

The tools of the African potter are often simply natural objects such as seed pods, bits of skin, pebbles and the like which save the potter time in smoothing the pot. Sometimes a wooden pestle may be used to pound the clay, and, rarely, small clay pestles to beat the clay into a prepared mould. The most elaborate tools are the carved wooden or plaited-fibre roulettes for making impressed decorations in the damp clay of the pot before it is dry.

Apart from impressed decorations, other patterns can be incised with a knife or stick after the pot is dry, or they can be painted on after firing. Sometimes the painting is burnished with the aid of a stone or strings of seeds. Very often there is a combination of these different decorations.

The arrangement and date of the pots in this exhibition

The pots are arranged in the exhibition cases on a geographical and cultural basis. They range in date from 1969 to some 150 years ago, except for the archaeological material, much of which may be older than this. The individual cases are discussed below in what may be a convenient order for visitors to the exhibition.

Ghana: sacred pottery

The pots in this case, though retaining obvious pot form, are all elaborated by sculptured ornament to a greater or less degree. Nine of the eleven are from the Ashanti and of these the most important are the *abusua kuruwa* and *mogye-mogye* pots.

Kuruwa means an elaborate drinking-water pot made

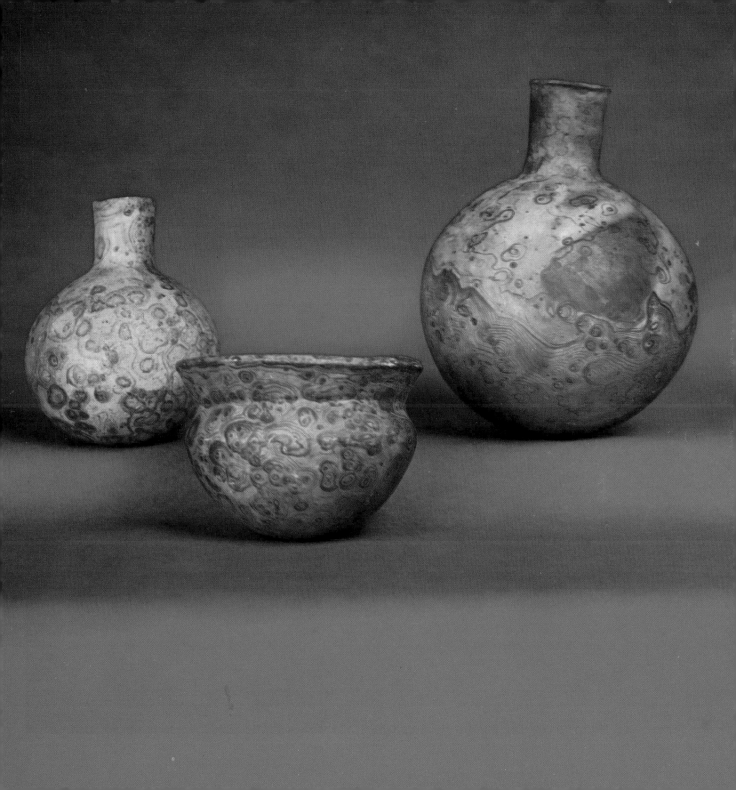

Before and after firing in the village of Oja, Akoko-Edo district, a mainly Edo-speaking area north of the Benin kingdom, Nigeria. The woman in the left background is about to remove a pot from the hot ashes. Photograph: Susan Picton 1969

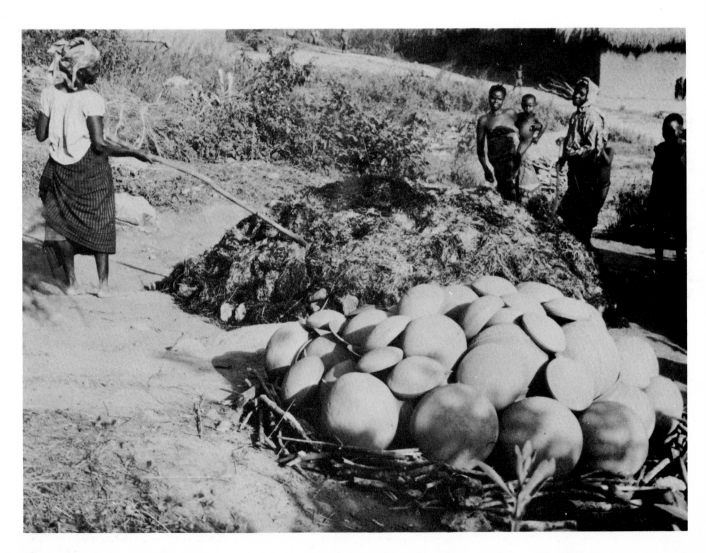

Pots from Oja on the fifteen-mile
journey to Igara to be sold in the market.
Photograph: Susan Picton 1969

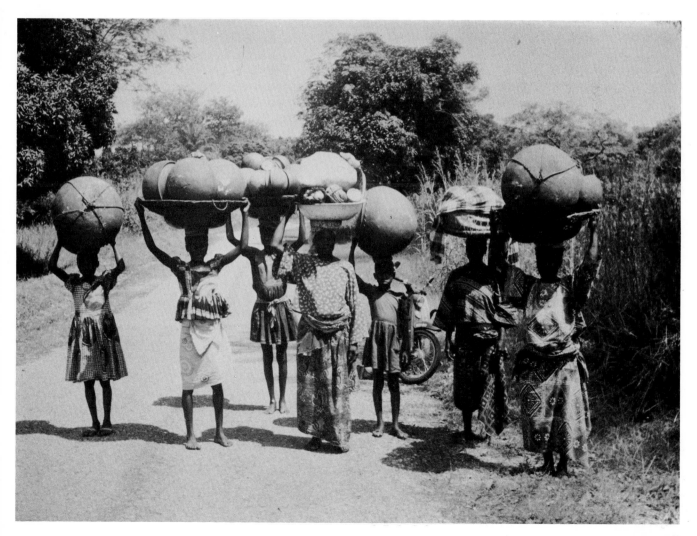

by men, and *abusua* means family or class. These 'family pots' are prepared for ceremonies which follow the burial of a deceased Ashanti. All the blood relatives shave off their hair and put it inside the *abusua kuruwa* which is then deposited together with a cooking pot and utensils, hearthstone, and sacrificial food at the burial ground – not on the actual grave, however, but at a part set aside as 'the place of the pots'. One of the *abusua kuruwa* on display is standing on three small up-turned pots representing *bukyia*, hearthstones.

The Ashanti tradition whereby pots with anthropomorphic and zoomorphic decoration are made by men rather than by women (as are all other Ashanti pots) has already been referred to.

Mogye-mogye apparently means 'jawbone', and this 'jawbone pot' used to contain the wine poured out as libations over the Golden Stool of Ashanti. This is a very beautiful pot and the decorative patterns resemble Ashanti gold-work designs (and like them may be derived from European forms).

The two non-Ashanti pots in this case are the imitation water barrel from the Ewe, and an elaborate pot from the north of Ghana which somewhat resembles the form of some of the large Kabyle vases from Algeria.

Ghana: terra-cotta sculpture

The sculptures in this case are all from southern Ghana and most, if not all, especially the Ashanti examples, were collected from graveyards and are therefore memorial sculptures associated with funeral ceremonies. There are two pairs of heads larger than all the other objects. One pair came from Kajebi in northern Ewe country and were probably made over 150 years ago by the Kwahu, an Ashanti group who lived in that area at the time but later moved on. The other pair are from Fomena in southern Ashanti south of Kumasi. The figure is from Kafudidi east of the Huni valley railway station, in Fante territory; nothing further is known about it.

Ghana: useful pots

These are all purely utilitarian pots, in contrast with the other two cases of Ghanaian material. The very large pot in the centre of the case is for water storage in the house, and is from a village in Ada district at the mouth and in the lower reaches of the Volta River, an area inhabited mainly by the Ga-Adangme people. Other tribes represented are the Ashanti, Bron, Gonja and Namnam.

Cameroon Grasslands

This collection of pots from the Bamileke tribes of Cameroon are for various purposes, and include skeuomorphs, that is representations of utensils in other materials complete with details which were necessary features of construction in the original material, but are carried over as decoration (see for example the representation of a calabash in characteristic cane harness).

The Gbaya of Central Cameroon

These eight pots were made by a Gbaya woman and collected for the British Museum in 1969 by the University College of Wales Expedition to Central Cameroon.

The Gbaya are among the most famous of African potters. Most of their wares are burnished with graphite.

The Western Congo

This pottery is a selection from the immensely varied repertoire of pots produced by the great Bakongo complex of tribes which surrounds the Congo mouth and stretches for some hundreds of miles inland. Among them are four figure sculptures by the potter Voania Muba, who developed a style of his own and flourished around 1900; he learnt from Europeans how to inscribe his name on the pots. Among them also are a selection of pots with unusual and very beautiful decorative effects produced by splashing them with vegetable matter when hot.

The Congo

For both this and the previous case the term Congo does not refer to any political boundaries but to the area within the watershed of the great Congo River and its tributaries, and thus includes peoples such as the Azande who inhabit an area between the watersheds of the Nile and Congo on both sides of the border between the Sudan and Congo–Kinshasa and the Central African Republic. Also included are the peoples of Rwanda, represented here by a series of pots made by the Batwa Pygmies for the Batutsi, the traditional nobility of the country. These pots are mainly for drinking honey beer. A major group of pots in this case are those from the Bakuba which, when not in use, are hung on the framework of the wall inside their huts.

North-east Africa

The pottery in this case is all domestic ware from the Sudan, Ethiopia, Somalia and Kenya.

East Africa

Most of the pottery in this case is from Uganda together with two from Tanzania and one from the Abarundi, the inhabitants of Urundi (although this particular example was collected over the border in Tanzania). The most remarkable of these pots are perhaps those made in the form of calabashes – a trait more suggestive of an almost Japanese sophistication than of a primitive survival. The two many-mouthed pots are said to be for use in ceremonial, but the remainder are probably for domestic use.

The Luzira Head

This collection of terra-cotta sculptures, pottery and other objects comes from Luzira Hill near Port Bell on Lake Victoria, Uganda. On top of the hill was a shrine consisting of the four-legged pot containing some coins, and surrounded by some iron spear heads and various pottery objects. The coins date from 1922 to 1928. The remainder of the objects exhibited here were excavated in 1930 from three holes about a quarter of a mile from the shrine. The head and the torsos are remarkable in that they are quite unlike anything else known from that area of Africa, or indeed elsewhere. However, it is not possible to attribute a specific age to them and no association can be assumed between the shrine and the pits. The significance of the shrine is unknown. If we assume the terra-cottas to be several hundred years old,

Pots made at Oja on sale in Igara,
the principal market of
Akoko-Edo.
Photograph: Susan Picton 1969

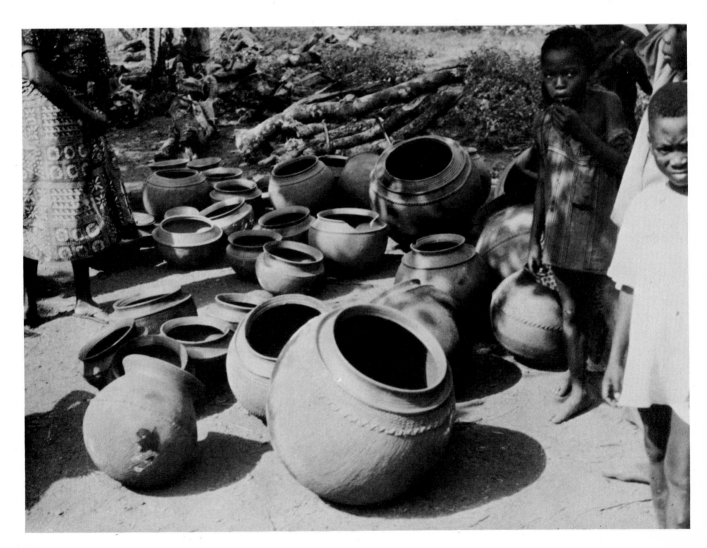

Mogyemogye, 'jawbone' pot, which
contained the wine kept for pouring over
the Golden Stool of Ashanti, Ghana,
from Abuakwa village north-east of
Kumasi. 18in (46cm)

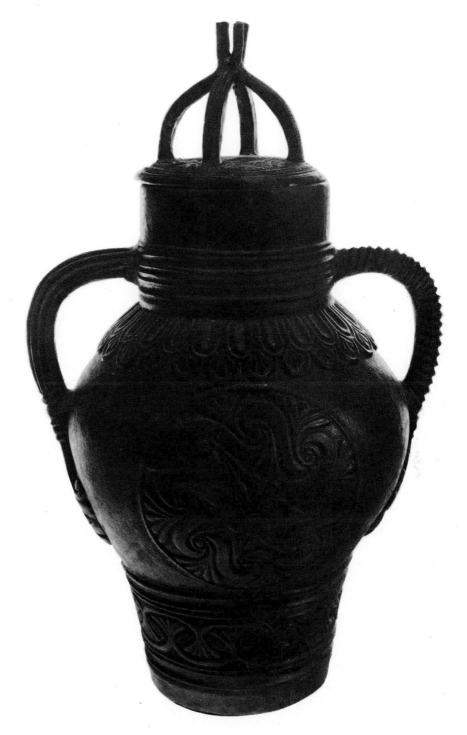

it does not seem at all likely to be an isolated phenomenon in the Uganda area, and we may hope that further examples of this most interesting style will emerge when systematic excavations are undertaken.

Southern Africa

'Southern Africa' here includes Zambia, Rhodesia, Botswana and Lesotho, as well as the Republic of South Africa. Many of the pots in this area, and particularly those of the Bapedi, are carefully decorated with geometric patterns, coloured with red slip, graphite and chalk, and burnished.

The pots of the Barotse of western Zambia, the Basotho of Lesotho and the Bavenda of South Africa and the adjacent area of Rhodesia are still very much alike, and sometimes indistinguishable, although they are now hundreds of miles apart after dispersing from a single centre about two centuries ago. This presumably reflects the far greater homogeneity of the Bantu-speaking peoples in contrast with the diversity of West Africa.

Northern Nigeria

The term 'Northern Nigeria' is the old administrative term for the area covered by this case, i.e. the Benue and middle Niger valleys northwards. It roughly (though inaccurately) divides into the so-called Middle Belt which is largely 'pagan', and the area north of it which is predominantly Islamic. In 1968 the administrative use of 'Northern Nigeria' was dropped and the area was divided into six states. It is here used in a geographical sense.

Among the pottery displayed here is a remarkable lamp from the Nupe of the Middle Niger valley. The pot drum may also be regarded as unusual, but is merely one example of a type of drum which is widespread throughout West Africa. One of the domestic wares in the case, a large spherical pot, is made by the Adarawa Hausa of Sokoto who were mentioned earlier in this booklet.

Northern Nigeria: terra-cottas

In contrast to the previous case, there are exhibited here examples of pottery sculpture from northern Nigeria, although it must be admitted that, as with Yoruba pottery, the British Museum collections are less than representative. However, some impression is given of the great variety of sculptural forms in this medium. The two seated figures by the famous Goemai woman potter Azume (*ob. c.* 1951), once common in the area, are said to have had no ritual purpose.

The terra-cotta sculpture of the Nok Culture and its possible relationship to the varied traditions of the recent past and the present day in northern Nigeria were mentioned earlier in this catalogue. The Nigerian region is at present to be credited with the earliest known pottery in sub-Saharan Africa as well as the most remarkable and ancient terra-cotta sculpture.

The Yoruba

There is a very great deal of pottery and terra-cotta made by the Yoruba people of western Nigeria at the present day and in the recent past, but it is not yet very well represented in the British Museum collection.

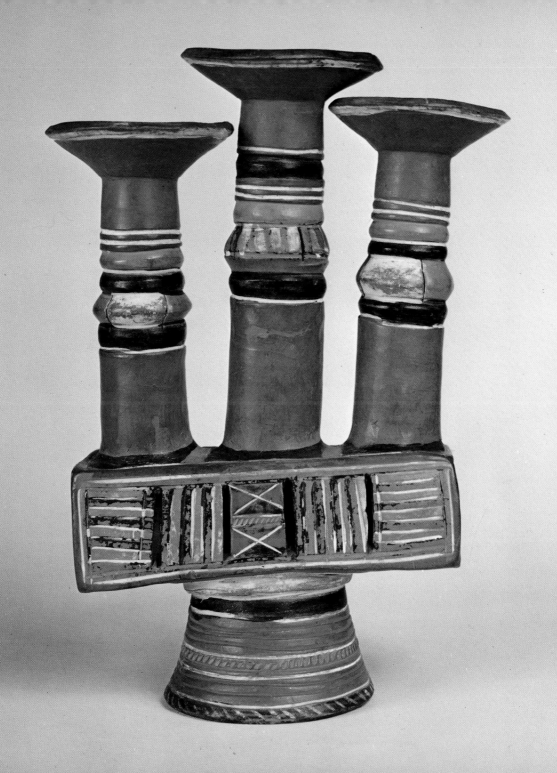

Terra-cotta head from Kajebi in northern
Ewe country, probably made over 150
years ago by the Kwahu, an Ashanti
group living there at the time. 15in (38cm)

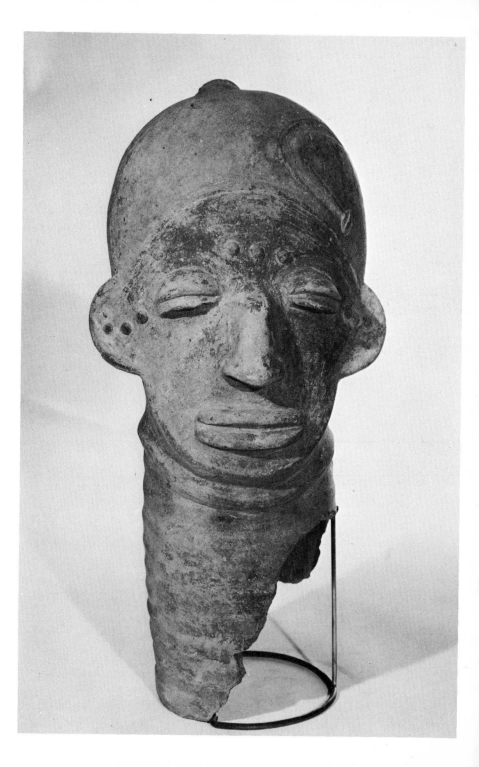

Vessel made in the form of a calabash,
from the Bamileke of the grasslands of
Cameroon. 8in (21cm)

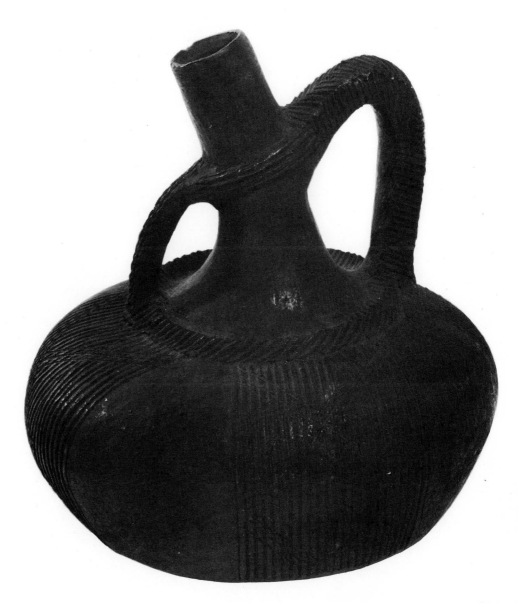

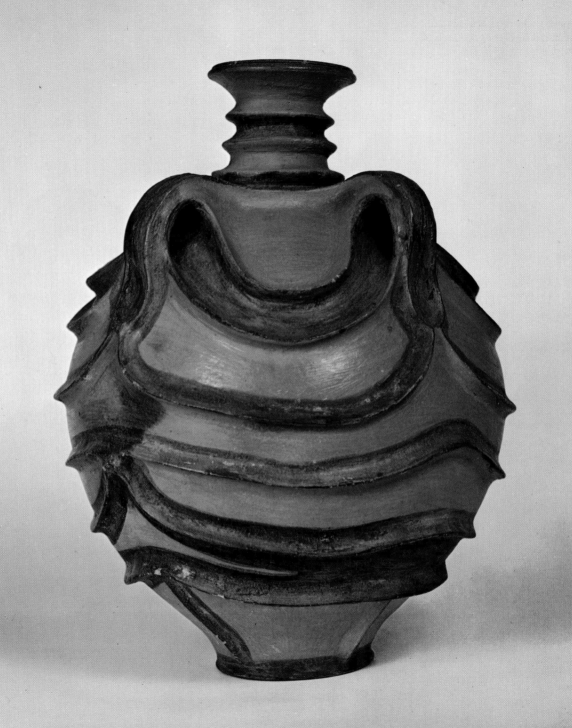

Pot with moulded ornament probably from Inyenye village in northern Ibo country, Nigeria. 17½in (44cm)

A few examples of domestic ware are shown, together with some of the more elaborate ritual pottery.

Most of the Yoruba cults of the gods make use of pots among the various paraphernalia associated with them, and these pots are often ornamented. The most elaborate come from the south-western area of Yoruba country, on the border with Dahomey. All of this pottery, whether for ritual or domestic use, elaborate or simple, is made by women potters. The sculpture tradition of Ife seems to have no descendants in present-day Yoruba sculpture, although it does at Benin where the bronze-casters continue the tradition of *cire perdue* as well as terra-cotta sculpture which is believed to have been derived from Ife.

One exceptional object is, however, displayed in this case; that is the pottery head in a style very different from the sculpture of Yoruba women potters, but identical in style with much of Yoruba bronze-casting, especially in the Ijebu area. It may well have been made by a (male) bronze-caster for the cult (no doubt that of the Earth, worshipped by the Ogboni or Oshugbo Society) which he served.

The Ibo of Nigeria
The pots in this case are enormously varied in shape, colour, texture, and style and thereby provide ample evidence of the great variety of Ibo culture in general. Perhaps the most beautiful pot is that with fluted decoration from Inyenye in the north of Ibo country. Also remarkable is the ceremonial double vessel from either Awka or Aguleri in the north-west of Ibo territory. Food is placed in one dish and wine in the other.

The ornamentation of this pot is remarkable in that it forms a bearded (but highly stylised) human face under each bowl.

Western Ibo
These terra-cotta groups together with the pot decorated with a series of figures were made for the cult of Ifijioku, the Yam Spirit, at Osisa, an Ibo village north of Aboh on the west bank of the lower Niger. They were placed as ornaments in outdoor shrines dedicated to Ifijioku. The figures represent family heads with their wives and attendants. No intact specimens remain at Osisa. Those displayed here were mostly collected about 1880. The smaller group on a rectangular base, recently acquired, may date from early this century and probably came from Osisa or nearby.

Eastern Nigeria
These pots are mostly of uncertain use, from the Ejagham (or Ekoi) of the area east of the Cross River towards the border with Cameroon, and from the Ibo of the central area of eastern Nigeria. The Ejagham pots are distinguished by their subtle painted 'art nouveau' patterns.

The large perforated pot is either for drying meat or, more probably, for washing farm produce such as cassava or locust beans.

The Ibo and Ijo
The ten Ijo pots were made by the Okrika clan of the Ijo tribe, to the eastern side of the Niger delta, for use in their ancestor cult. The Ibo pots are for a variety of

purposes. The largest is perforated at the base and is used for straining or filtering. Another of the Ibo pots is a friction drum; when the string which originally was passed through the membrane and anchored inside the cover of the pot, but is now missing, was held taut and rubbed, 'terrifying noises' are said to have been produced.

The Kabyles of Algeria

The Kabyles (Arabic *kabail,* 'tribes') are a great Berber tribal complex inhabiting the Djurdjura mountains, a part of the Atlas to the east of Algiers, as well as the hilly country to the east around Constantine. They are primarily agriculturalists and, besides a great reputation as jewellers in silver, they are famous for their ancient tradition of making and decorating pottery. While there is a recognisable Kabyle style, considerable variations occur between one group of villages and another. The tradition found at Toudja village about 20 kilometres west of the port of Bougie between Great and Little Kabylia, along the coastal areas of Little Kabylia, and in the hinterland between Philippeville and Constantine, has been recognised as preserving with remarkably little change an elaborate and idiosyncratic style first found in neolithic Cyprus about 2000 BC. This 'white-faced' style appears in various forms, usually with geometric decoration in brown and black.

Another distinctive style is that of the Beni Yeni ('sons of heaven') who live in the central area of Great Kabylia, and who are considered the best jewellers of the Kabyles. Most of the other pots are in styles associated with Fort National in the western area of Great Kabylia, except for a vessel and a dish in the style of Palestro in the south-west.

Vessel for honey beer made by the
Batwa Pygmies of Rwanda. 6½in (17cm)

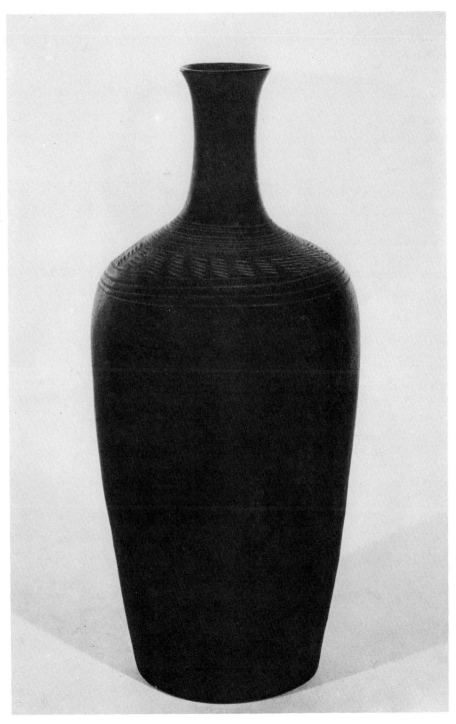

From the Azande, Sudan. 9¾in (25cm)

Three pots in styles associated with the Fort National and western areas of Great Kabylia, Algeria. 9¾, 22½ and 9¼in (25, 57 and 24cm)

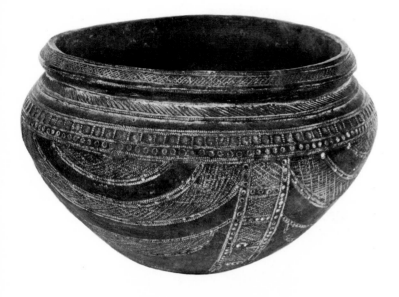

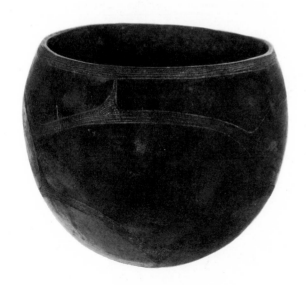

From the Litofa tribe of the Nuba hills, Sudan. 6¾in (17cm)

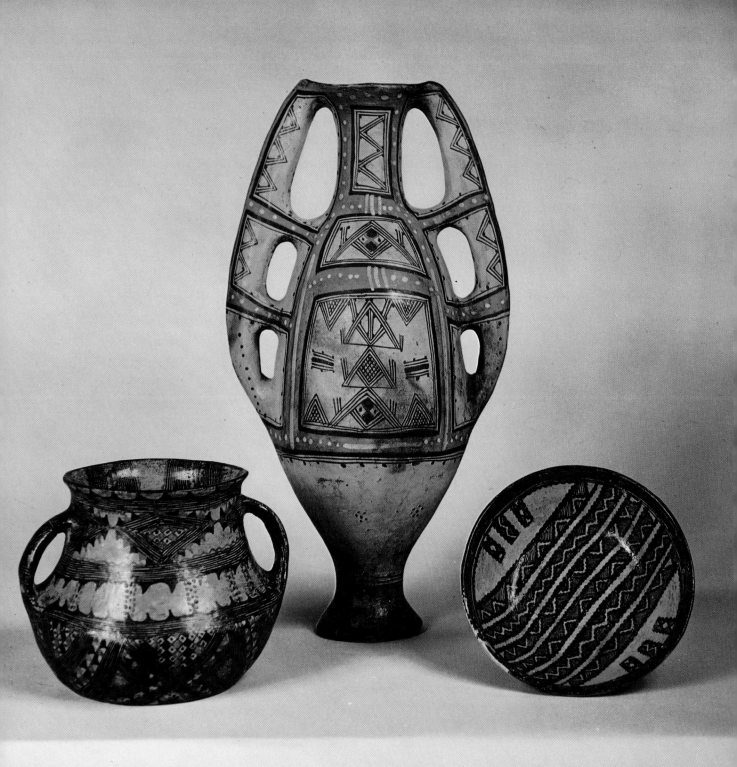

Pot shaped like a calabash ladle,
probably from the Baganda, Uganda.
8½in (22cm)

Terra-cotta head with body fragments
discovered on Luzira Hill near Port Bell
on Lake Victoria, Uganda. 15in (38cm,
excluding lowest body fragment)

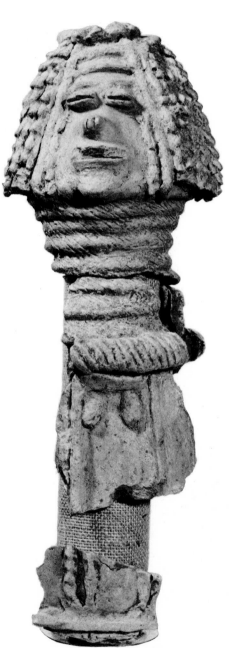

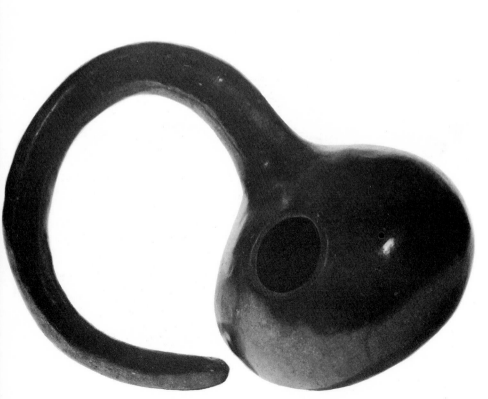

32

LIST OF EXHIBITS

The exhibits are listed by display cases in
a convenient order for the visitor.

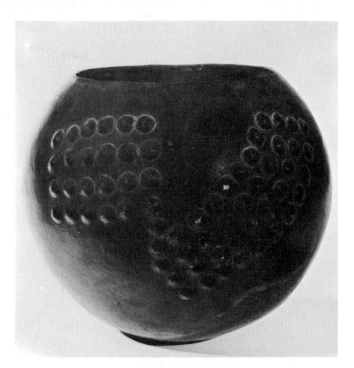

From the Zulu, South Africa. 10in (25cm)

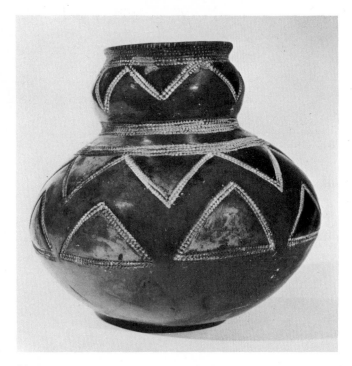

Milk vessel, from Botswana. 10½in (27cm)

Ghana: sacred pottery

Large pot collected before 1900 by Sir Cecil Armitage, northern Ghana
NN

Funerary pot, Bibiani, Ashanti; Capt. R. P. Wild
1936 10–22 11

Lamp, Bibiani, Ashanti; Capt. R. P. Wild
1935 3–14 6

Funerary pot on three small upturned pots, Abuakwa, Ashanti; Capt. R. P. Wild
1935 12–12 2

Large ceremonial pot collected in 1935 by Capt. R. S. Rattray, Abuakwa, Ashanti
1938 10–4 1

Funerary pot probably collected in 1873 by Sir Garnet Wolseley, Kumasi, Ashanti; Dowager Viscountess Wolseley
1917 11–13 11

Dish collected by Capt. R. S. Rattray, Ashanti
1938 10–4 4

Funerary pot, Adubiasi, Ashanti; Capt. R. P. Wild
1933 11–8 2

Barrel-shaped pot, Kpandu, Ewe; Mr E. T. Gikunoo
1907 1

Ghana: terra-cotta sculpture

Figure of a woman, Kafudidi; Capt. R. P. Wild
1936 11–7 1

Two heads in similar style; E. A. L. Martin Esq
1934 12–1 22, 23

Head, in Kwahu style, Ashanti
1966 Af4 1

Head by Kwahu (Ashanti) people settled in an Ewe district; Capt. R. P. Wild
1936 3–7 11

Head, northwest of Dunkwa, Fante; Capt. R. P. Wild
1935 1–7 1

Two large heads by Kwahu people settled in an Ewe district; Capt. R. P. Wild
1936 3–7 1, 2

Two large heads, Fomena, Ashanti; Capt. R. P. Wild
1933 12–2 1, 2

Two rudimentary figures, Hwidiem, Ashanti
1970 Af2 1, 2

Ghana: useful pots

Cooking pot, from Pankronu, Ashanti, on a brazier
1952 Af27 1; NN

Cooking pot
1952 Af27 21

Water storage pot, Dugame, Ada, R. Volta
1952 Af27 26

Two pots, Yeji, Gonja
1952 Af27 5, 7

Double-necked pot, Bron; Capt. R. P. Wild
1937 10–15 3

Pot, Nangode, Namnam; Capt. R. P. Wild
1935 10–9 1

Water pot, Pankronu, Ashanti
1952 Af27 13

Cameroon Grasslands

Five pots, Bamileke
1937 2–17 18, 19, 22, 24, 27

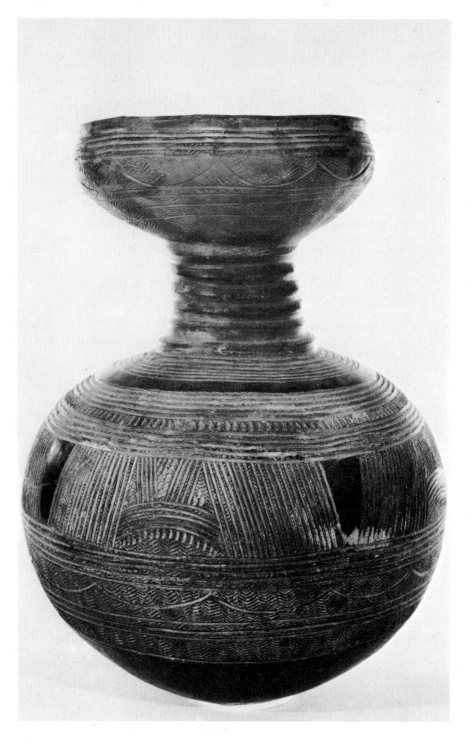

Pot from Budon, a village of the Kakanda tribe, on the middle Niger just north-west of the Niger-Benue confluence. 17½in (44cm)

36

Pottery figure made by Azume, a famous woman potter of the Goemai tribe, northern Nigeria, who died about 1951. 11½in (29cm)

The lid of a cult pot from the south-western corner of Yoruba country, Nigeria. 10¾in (27cm)

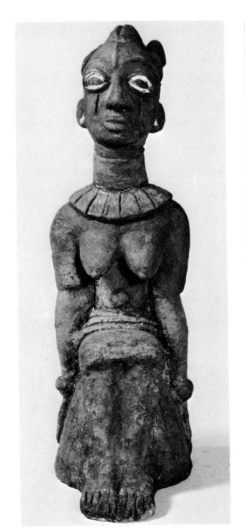

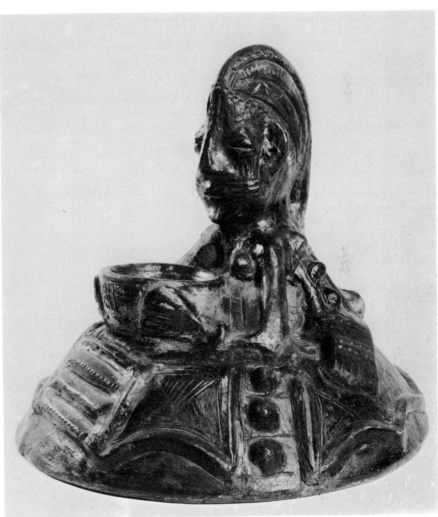

The Gbaya of Cameroon

Eight pots
1969 Af35 1–8

The Western Congo

Small hanging pot, Bakongo
W 1054

Four pots surmounted by figures or by a
head, Bakongo
W/NN

Three pots, Bakongo
1910 10–26 1, 3, +5765

Pot, Bakongo
W 43646

Larger pot, Bakongo
W 1031

Small but elaborate pot surmounted by
a head
W 41821
Note: The prefix W indicates a piece
presented in 1954 by the Trustees of the
Wellcome Historical Medical Museum.

The Congo

Pot suspended from the wall of a hut,
Lusambo, Bakuba, Congo–Kinshasa
1909 Ty 1063

Four others, smaller, Bangongo, Bakuba,
Congo–Kinshasa
1908 Ty 355, 359, 363, 366

Dish, Pianga, Bakuba, Congo–Kinshasa
1951 Af12 310

Two pots, Bangongo, Bakuba,
Congo–Kinshasa
1908 Ty 378, 380

Small pot, Sungu, Batetela,
Congo–Kinshasa
1909 Ty 892

Three small pots, Batwa, Rwanda; Mrs
M. Jackson
1940 Af16 63–65

Another, Batwa, Rwanda; Capt. J. E.
Philipps
1921 5–12 19

Another, Batwa, Rwanda
1948 Af8 48

Two pots surmounted by heads, Buri,
Mangbetu, Congo–Kinshasa
1921 1–8 1, 3

Cooking pot, Azande, Sudan
1931 3–21 41

Pot surmounted by the figure of a woman,
Azande, Sudan; C. Beving Esq
1934 3–8 27

Dish with fibre handle, Azande, Sudan
W 43598

Large pot surmounted by a head, Azande,
Sudan
1931 4–11 3

North-East Africa

Pot, Litofa, Nuba, Sudan; Prof. C. G.
Seligman
1928 3–7 19

Two pots, Kadaru, Nuba, Sudan
1948 Af6, 8, 9

Three pots, Ethiopia; Sir Claud F. Russell
1936 7–11 21, 35a, 40

Pot, western Suk, Kenya
NN

Two pots, Bimal and Rahanwin-Eile,
Somali; Major and Miss Powell-Cotton
1935 11–8 80, 81

Pot, Jomvu, Mombasa, Kenya
1906 7–3 3

East Africa

Milk pot, Banyoro, Uganda; Major
Ashburnham
1914 4–4 1

Three pots, Baganda, Uganda; Sir H. H.
Johnston
1901 11–13 44, 46, 49

Two pots shaped like calabashes, Baganda,
Uganda; Sir H. H. Johnston
1901 11–13 50, 51

Calabash of similar shape to 1901.
11–13.50, Uganda
NN

Calabash of similar shape to 1901.
11–13.51, South Africa; Sir Bartle Frere
1910 10–5 75

Milk pot with sling and basketry stand and
lid, Banyankole, Uganda; Sir H. H.
Johnston
1901 11–13 44a

Large ceremonial pot with five mouths,
Bagishu, Uganda; Mrs K. M. Trowell
1939 Af25 7

Pot, Ruwenzori mountains district,
Uganda; National Art-Collections Fund,
London
1955 Af10 1

Ceremonial pot with three mouths,
Uganda; Rev. Ernest Millar
1902 7–18 11

Two pots, Abarundi, Tanzania/Urundi;
J. S. Darling Esq
1932 12–3 7, 8

Uganda: The Luzira Head

The entire collection of objects, including
a terra-cotta head with associated torso,
fragments of at least three other torsos, pot,
iron spear heads, coins, potsherds and
other pottery objects, all from sites on
Luzira Hill, near Port Bell on Lake
Victoria, Uganda; E. J. Wayland Esq
1931 1–5 1 to 136

Southern Africa

Pot, collected before 1865, Basotho,
Lesotho
476

Cooking pot, Basotho, Lesotho
+5165

Pot, Basotho or Barotse (Zambia); Mrs
Wharton
1947 Af7 8

Similar pot, Basotho, Lesotho
1967 Af8 1

Pot, Bavenda, South Africa; Mrs F. J.
Newnham
1945 Af4 15

Large milk pot, Botswana
1910 423

Pot, Barotse, Zambia
1924 6

Two pots, Mambunda and Barotse
respectively, Zambia; Bernard Carp Esq
1953 Af10 5, 7

Pot, Mashona, Rhodesia; J. T. Bent Esq
1892 7–14 148

Water and cooking pot, Awemba, Zambia;
Chief Secretary, Government of Northern
Rhodesia (1933)
1933 12–6 52

Two pots, Kaonde, Zambia; W. H.
Curry Esq
1968 Af1 4, 6

Pot, Bapedi, South Africa; E. A. L.
Martin Esq
1934 12–1 6

Two pots, Bapedi, South Africa;
I. S. Wansbrough Esq
1933 1–9 3, 5

Southern Africa (*continued*)

Pot, Zulu, South Africa; E. A. L.
Martin Esq
1934 12–1 5

**Tools used by Hausa (Jaba) women
potters at Kwoi and Nok, Nigeria,
collected by H. J. Braunholtz Esq**

Pieces of skin, loofa, calabash and iron
1946 Af18 170–173

Two pieces of wood
1946 Af18 174–175

Seven fibre roulettes
1946 Af18 176–182

Two pieces of reed
1946 Af18 183–184

Lumps of clay
1946 Af18 186–187

Grit
1946 Af18 188a, b, c

Wooden roulette
1946 Af18 244

**Tools used by Adarawa Hausa men
potters at Sokoto, Nigeria, collected
by W. E. Nicholson Esq**

Three pestles
1927 12–8 5–7

Pot-repairing tool
1927 12–8 8

Pottery disc
1927 12–8 9

Piece of skin
1927 12–8 11

Strings of baobab seeds
1927 12–8 12

Northern Nigeria

Porridge or beer pot, Jarawa
1951 Af12 91

Large ceremonial pot, Angas; C. K. Meek
1924 3–3 1

Three-legged pot
NN

Small water pot, Nupe
1904 11–28 11

Vessel collected in the 1890s, Nupe
1954 Af23 1245

Triple lamp, Nupe
5085

Water pot, Sokoto, Hausa
1946 Af18 381

Cooking pot on a brazier, Kano, Hausa
1946 Af18 247, 248

Percussion aerophone ('pot gong'), Gbari
1924 4–15 13

Tall pedestal pot, Fika, Kanuri; Mrs
Macleod
1911 12–14 17

Pot drum, Basa, Afo and Kwoto; Chief
Secretary, Government of Nigeria
1924 12–17 60

Pot for the cult of the Yam Spirit,
Ifijioku, at Osisa, an Ibo village north of
Aboh on the west bank of the lower
Niger, Nigeria; collected there about
1880. 19in (48cm)

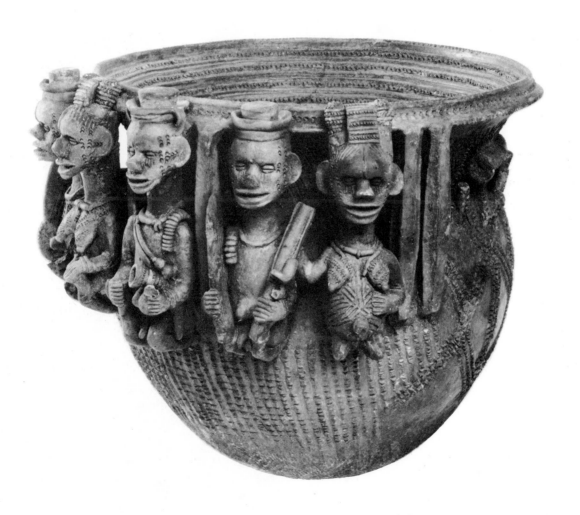

Ceremonial vessel from the Ejagham or
Ekoi people east of the Cross River,
Nigeria. 14in (36cm)

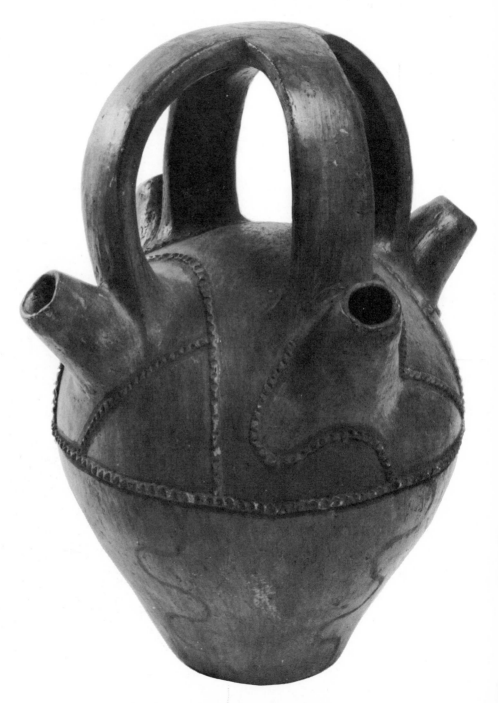

Pot for the ancestral cult, Okrika Ijo,
Niger delta, Nigeria. 19in (48cm)

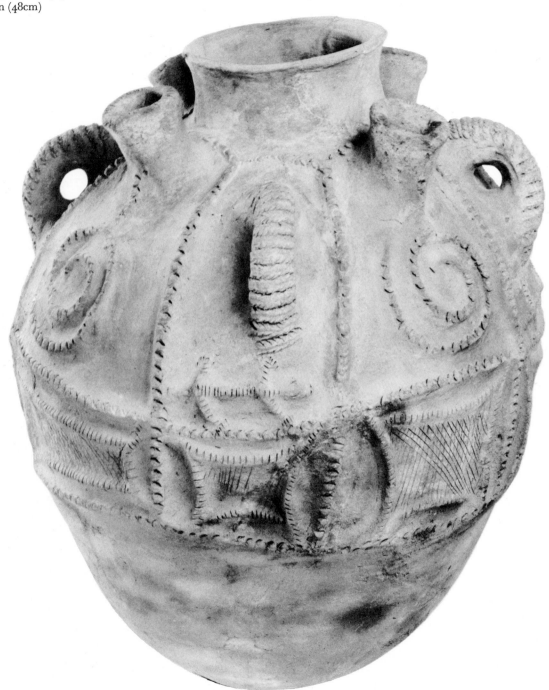

Northern Nigeria (*continued*)

Two water pots, Tula and Tangale
respectively
1951 Af12 102, 112

Water pot, Budon, Kakanda
1951 Af23 1249

Two pots, Koton Karifi, Igbira
1954 Af23 1250, 1251

Northern Nigeria: terra-cottas

Two terra-cotta figures of women by
Azume, Goemai
1947 Af29 1; 1950 Af3–1

Two elaborate pots, Lokoja; Mrs Macleod
1911 12–14 167, 168

Another, larger, probably from Lokoja
1951 Af25 1

Two terra-cotta camels, Sokoto, Hausa
1954 Af23 1493, 1497

Two dolls, Fika, Kanuri; Mrs Macleod
1911 12–14 1, 2

Two pottery objects, Longuda; S. W.
Walker Esq
1929 7–14 2, 8

Small pot, two heads and a bird, Waja and
Cham; Mr and Mrs C. L. Temple
1913 10–13 10, 47, 48, 49

Terra-cotta head, Tiv; Wukari Native
Administration, Nigeria
1932 5–16 30

Terra-cotta head, Tiv
1954 Af23 1141

The Yoruba of Nigeria

Terra-cotta head; Lady Menendez
1952 Af20 133

Ceremonial vessel with an elaborate lid;
Lady Menendez
1952 Af20 134

Ceremonial pot surmounted by the figure
of a woman; United Africa Co.
1935 11–10 43

Cover, surmounted by a head, for a
ceremonial pot
1954 Af23 263

Large pot, Nigeria–Dahomey border,
Yoruba or Egun (Popo)
+3934

Small pot surmounted by the figure of a
woman, Nigeria–Dahomey border,
Yoruba or Egun (Popo)
1954 Af23 264

Two pots, Abeokuta
1937 6–7 24, 25

The Ibo of Nigeria

Two pots for camwood
1954 Af23 1010, 1011

Pot, Abakaliki, north-eastern Ibo;
N. C. Duncan Esq
1908. 335

Large decorated pot, Inyenye, northern
Ibo; Chief Secretary to the Government of
Nigeria
1924 12–17 62

Double ceremonial dish, Awka or Aguleri,
north-western Ibo
1954 Af23 1012

Two water or wine pots
1954 Af23 999, 997

Many-necked ceremonial pot collected by
the donor, 1907–16, southern Ibo;
P. A. Talbot Esq
1950 Af45 29

Palm-oil pot, Uchi, presented in 1892;
Sir A. W. Franks
+6231

Percussion aerophone (pot gong) collected
by the donor, 1907–16; P. A. Talbot Esq
1950 Af45 85

Two pots collected 1907–16;
P. A. Talbot Esq
1950 Af45 31, 35

Pot from Kabylia, Algeria, preserving a
style first found in neolithic Cyprus about
2000 BC. 10¼in (26cm)

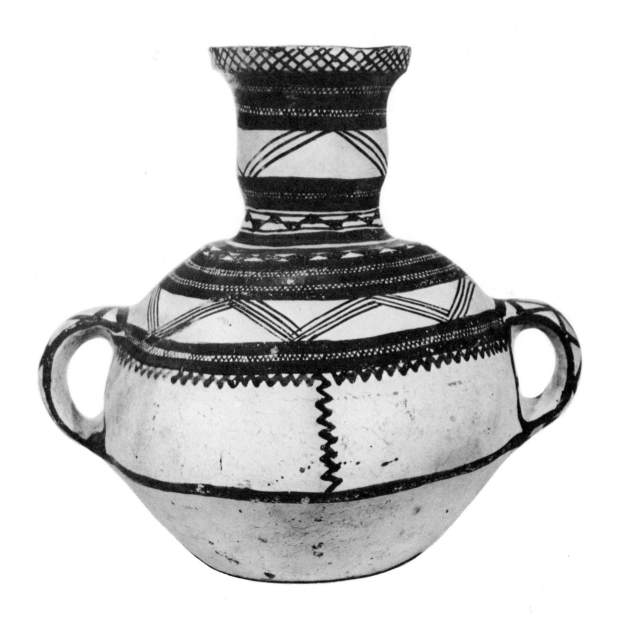

The Ibo of Nigeria (*continued*)

Two decorated pots
1954 Af23 1062, 995

Large pot with knobs
1954 Af23 1004

The Western Ibo

Three terra-cotta groups, Osisa, western
Ibo
1951 Af1 1; 1954 Af23 463; NN

Ceremonial pot decorated with figures,
Osisa, western Ibo
NN

Another group of three figures, probably
from Osisa or nearby
1969 Af9 4

Eastern Nigeria

Pot, Ejagham; P. Rattray Esq
1932 7–8 1

Another, Ejagham, 1901–08; collected
by the donor between 1901 and 1908;
C. Partridge Esq
1956 Af7 5

Another, Ejagham; L. J. Hooper Esq
1949 Af30 1

Two pots and a dish collected by the
donor, 1907–16, Ejagham; P. A.
Talbot Esq
1950 Af45 108, 109, 112

Ceremonial dish, Ibo (collected by
Robert Jamieson, 1840–50);
Rev. S. Mitchison
1937 2–12 1

Ceremonial five-necked pot, Ibo
NN

Two pots collected by the donor,
1907 16, Ibo; P. A. Talbot Esq
1950 Af45 192, 169

The Ibo and Ijo

Two pots, Ibo
1954 Af23 1001, 1003

Pot collected by the donor, 1907–1916,
Ibo; P. A. Talbot Esq
1950 Af45 104

Pot friction drum, Ibo
1954 Af23 1002

Very large sieve or colander collected
by the donor, 1907–16, Ibo;
P. A. Talbot Esq
1950 Af45 194

Ten ceremonial pots collected by the
donor, 1907–16, Okrika, Ijo;
P. A. Talbot Esq
1950 Af45 1, 3–10, 458

The Kabyles of Algeria

Large vase, Fort National area,
western Kabylia
2190

Smaller vase in the same style as above,
Fort National area, western Kabylia;
Mrs Eustace Smith
1898 9–14 7

Dish, Fort National area;
Mrs Eustace Smith
1907 10–16 1

Two small vessels from Toudja village
between west and east Kabylia;
Mrs Eustace Smith
1898 9–14.6; 1899 12–8.7

Pot; Mrs Eustace Smith
1899 12–8.1

Three pots, eastern Kabylia;
Mrs Eustace Smith
1899 12–8 5, 2, 6

Dish and small vessel, probably Palestro,
south-western Kabylia; Miss J. H. Brooke
1937 11–10 3, 7

Large pot from the Beni Yeni tribe in
the centre of Great Kabylia, Algeria.
19in (48cm)

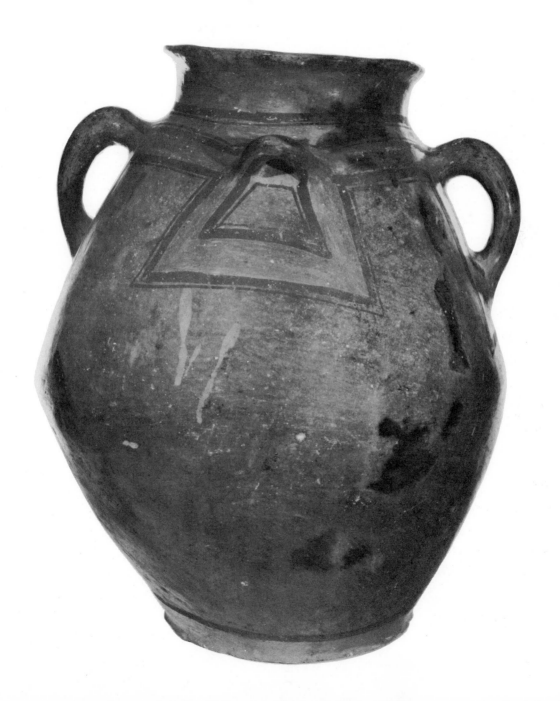

The Kabyles of Algeria (*continued*)

Pedestal triple dish, Fort National area,
western Kabylia; Mrs H. G. Beasley
1944 Af4 328

Two pots, Fort National area, western
Kabylia
1263; 1896 81

Vessel, Fort National area, western
Kabylia
1940 Af14 1

Large vase, Fort National area, western
Kabylia; J. H. Reynolds Esq
1922 10–19 1

Multiple lamp, Fort National area,
western Kabylia; G. J. Siming Esq
1961 Af15 1

Two pots from the Beni Yeni;
Mrs Eustace Smith
1898 9–14 11; 1898 9–14 10